letters of

Sr Wendy Beckett

to

Fr Kim En Joong

Title:	Letters by Sr Wendy Beckett to Fr Kim En Joong
ISBN:	978-1-925872-61-3 (paperback)
	978-1-925872-62-0 (hardback)
	978-1-925872-63-7 (epub)
	978-1-925872-64-4 (pdf)

INSTITUT KIM EN JOONG
www.kimenjoong.com

LCT Conseil
7, rue de la Félicité
75017 – Paris
France

ATF
THEOLOGY

An imprint of the ATF Ltd
PO Box 504 Hindmarsh
SA 5007
ABN 90 116 359 963
www.atfpress.com

Cover design by Myf Cadwallader
Graphic Design & Layout by Lydia Paton
Fonts: Fiona & Edwardian Script ITC

letters of

Sr Wendy Beckett

to

Fr Kim En Joong

2019

If Angels were to paint,
their art might be like that of Kim En Joong:
radiant, luminously beautiful, ecstatic in its
freedom.

*C*olour and form seem almost to
have appeared by virtue of their inherent
truth, not so much created by Father Kim
but summoned from the depths of his
prayer.

Letters by Sr Wendy Beckett to Fr Kim En Joong

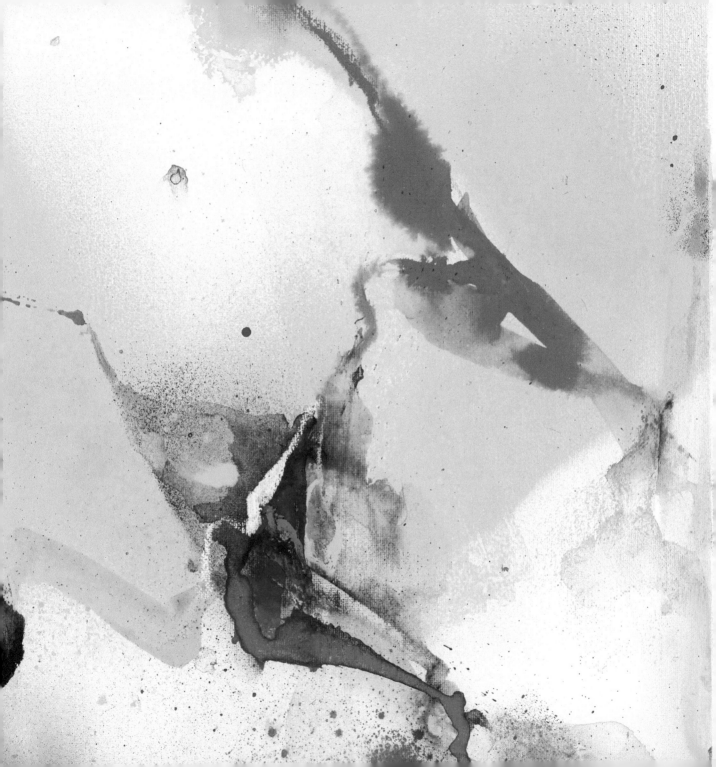

*D*ear Father Kim:

a small card but with immense love and

gratitude for the exquisite catalogue/

book. The search of God shines love with such

lucid glory.

*A*dmiringly, Sister Wendy

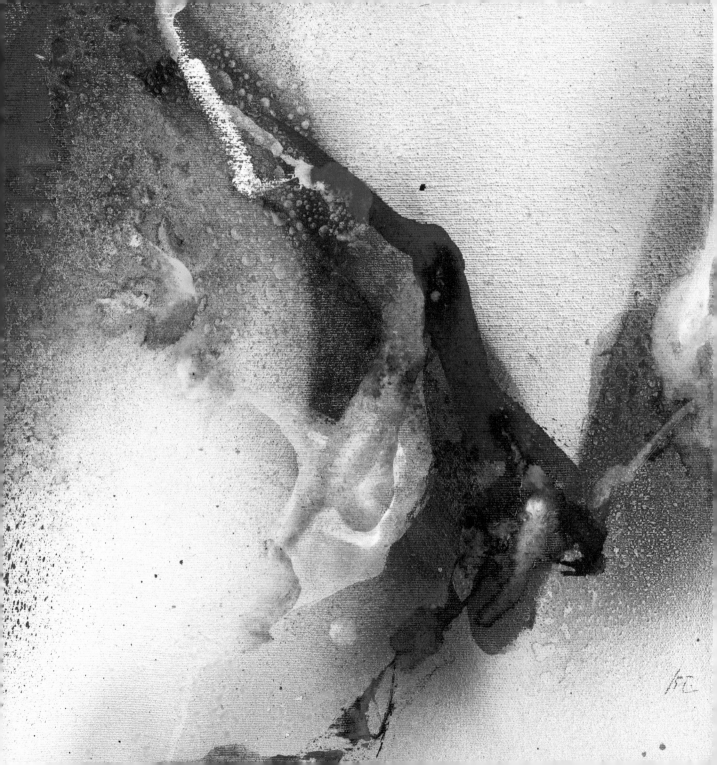

With best wishes for Christmas and the New Year. May the light of your art shine bright in the world's darkness.

Respectfully,

Sister Wendy

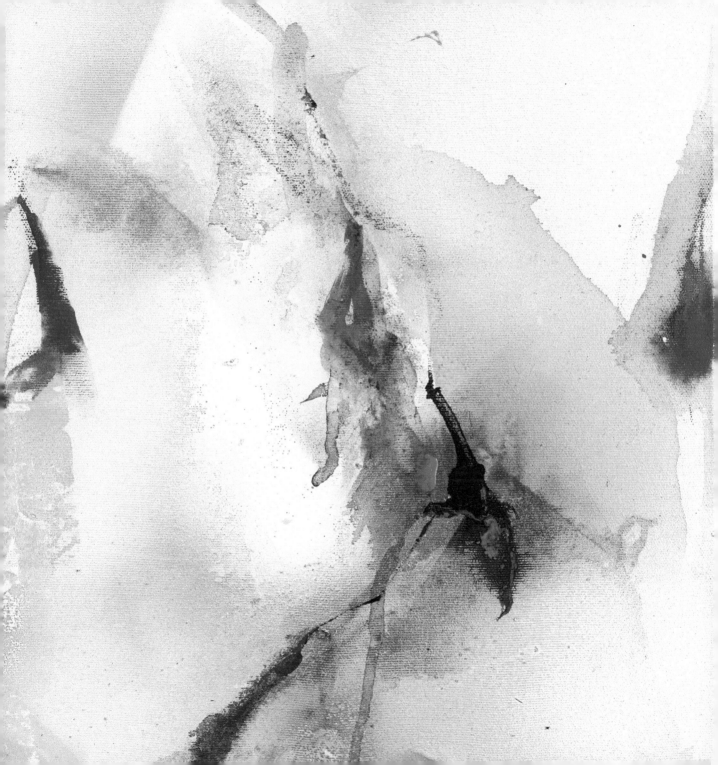

*D*ear Father Kim,
What a very generous gift! I myself won't
be able to see it – no matter – since the
community (I live above in silence) will
borrow one from their community room and
the prioress will tell me of its beauties.

*W*hat is for me is the photographs of
the window! The luminous Lord speaks –
reveals himself – through you. I glory in your
vocation.

*M*uch goodness, Sister Wendy

*L*etters by Sr Wendy Beckett to Fr Kim En Joong

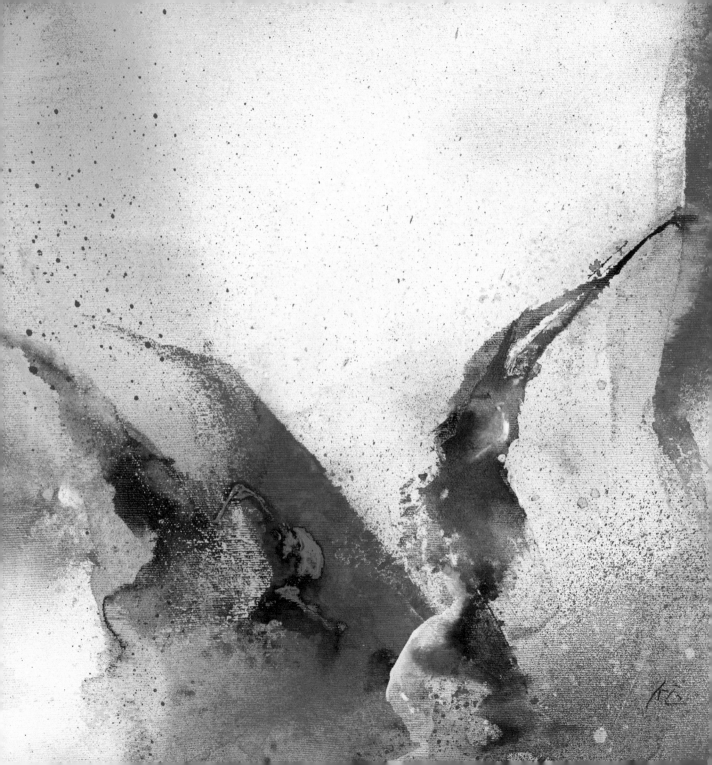

Dear Father Kim

My very best card to thank you and to rejoice

in the glory you give to God in making this

world more beautiful.

More a reflection of Christmas

Love,

Sister Wendy

Letters by Sr Wendy Beckett to Fr Kim En Joong

Dear Father Kim,

Please forgive me if I cannot accept. You know I love your work. But I am not well and have been told I must not undertake commissions. A whole page is quite a lot of writing and my poor spirit quails at the prospect. I can only ask for your gracious understanding. Look on me as your own art looks: all purity, fine, beauty, grace – infinite compassion.

Lovingly Sister Wendy

Letters by Sr Wendy Beckett to Fr Kim En Joong

\mathcal{D}ear Father Kim,

What a joy to receive these lovely books. The real joy is your art, what it reveals of the beauty of God. I feel so blessed to have contact with such a glory.

\mathcal{L}ove,
Sister Wendy

\mathcal{L}etters by Sr Wendy Beckett to Fr Kim En Joong

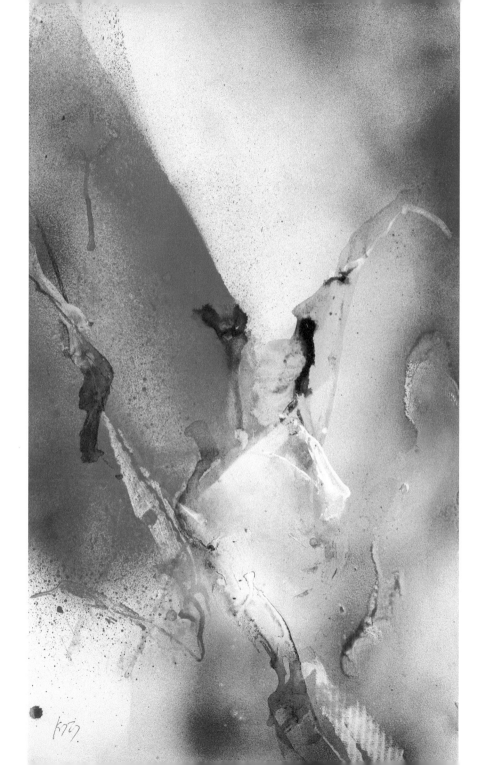

May Jesus be your joy now and always dear Father Kim.

Love,

Sister Wendy

I hope many hearts are filled with light – the Spirit's light – when they see your work.

Letters by Sr Wendy Beckett to Fr Kim En Joong

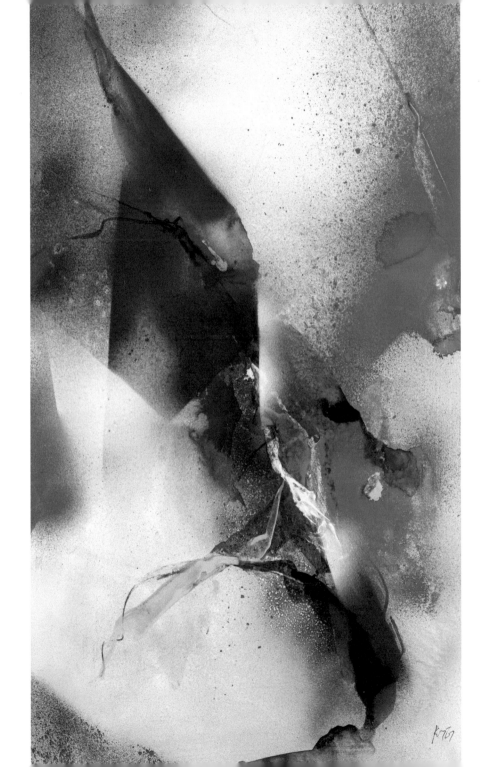

*D*ear Brother,

Your work amazes me with its purity, the luminous semblance (and the catalogue arrived the day before my birthday!)

I deeply love Korean ceramics and envy you your heritage. For once I can give you something, poor in comparison.

*L*ovingly Sister Wendy

*L*etters by Sr Wendy Beckett to Fr Kim En Joong

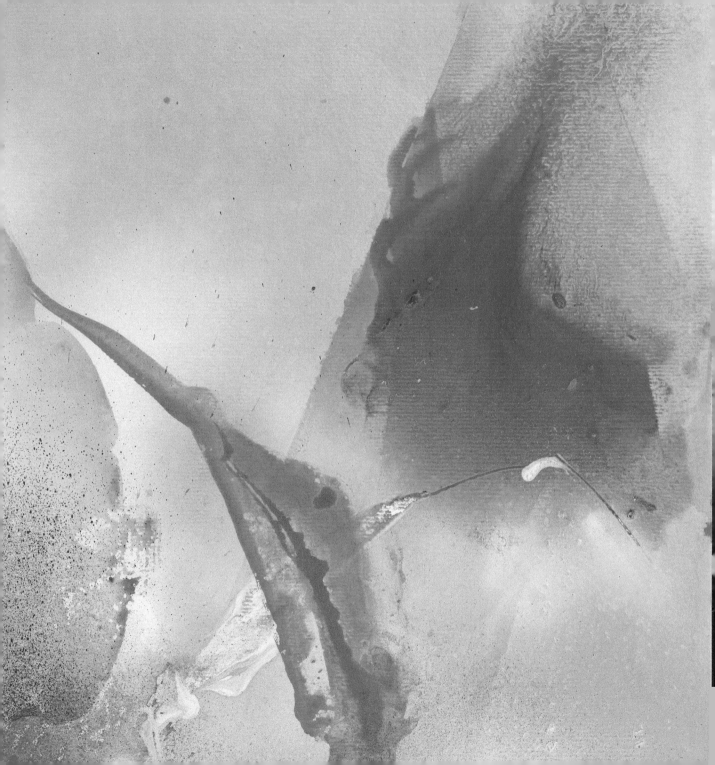

A happy Christmas from Sr Wendy.

*H*ow I wish, dear Fr Kim, something
worthy with which
to thank you.

Letters by Sr Wendy Beckett to Fr Kim En Joong

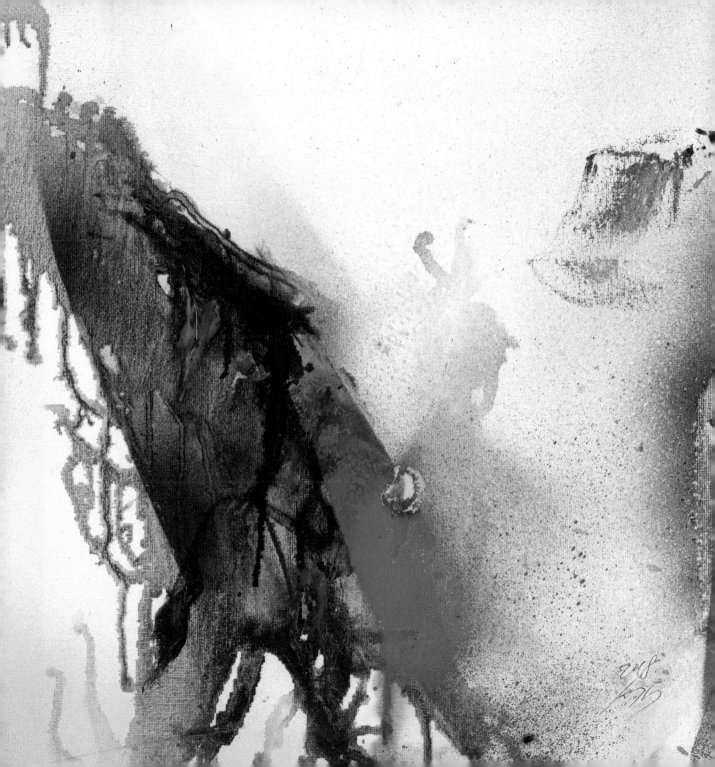

\mathcal{D}ear Reverend Fr Kim En Joong,

On the butterfly brightness of your art – its gossamer wings – you have flown out of sight of shore to a new land of peaceful beauty.

\mathcal{I}n admiration.

Sister Wendy

\mathcal{L}etters by Sr Wendy Beckett to Fr Kim En Joong

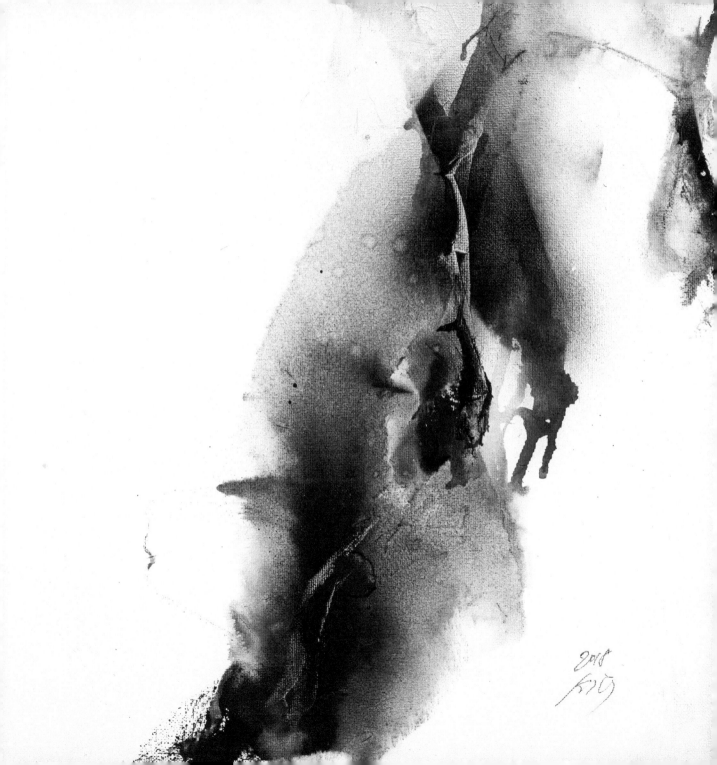

For Father Kim En Joong
Whom God has so profoundly blessed with a
sense of the unique and the means to make
it present.

Love

Sister Wendy

Letters by Sr Wendy Beckett to Fr Kim En Joong

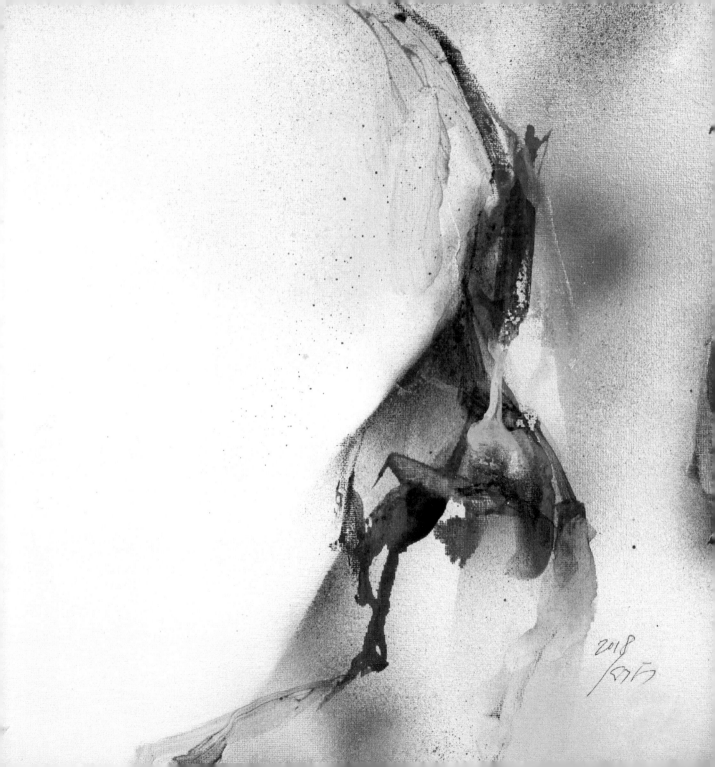

*D*ear Father Kim

For once it is I who have something to give!
I hope the books give you some joy, a gentle
preparation for the profound Feast of the
Sacred Heart this Friday.

*A*ffectionately,

Sister Wendy

*L*etters by Sr Wendy Beckett to Fr Kim En Joong

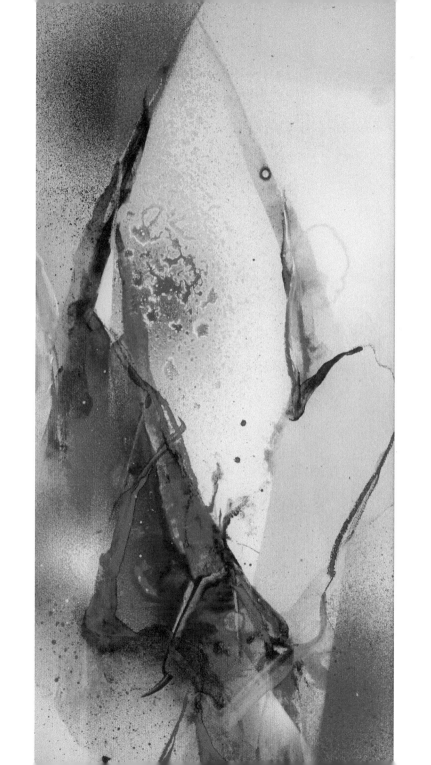

_W_ith best wishes for Christmas and the
New Year

May the light of your art shine bright in the
world's darkness.

_R_espectfully

Sister Wendy

_L_etters by Sr Wendy Beckett to Fr Kim En Joong

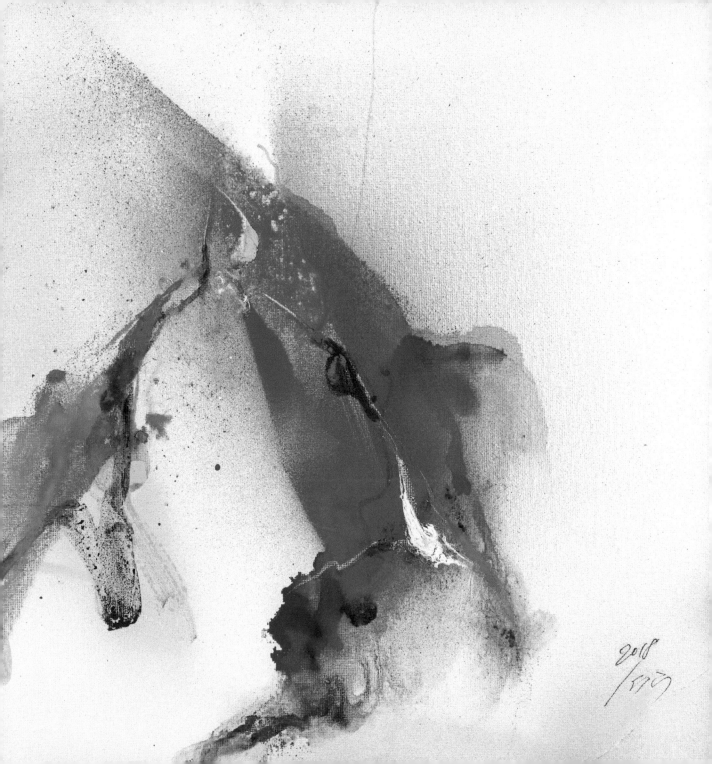

CPSIA information can be obtained
at www.ICGtesting.com
Printed in the USA
BVHW022324060819
555271BV00001B/2/P